WOMEN OF COLOR

JOAN HOPTON

Published in USA by Trinity Publishing Company

ISBN: 978-1-964707-00-6

Book Cover by Nellie Griffith
Editing by Nellie Griffith
Graphics by Joan Hopton, author

All pictures are originals, and the medium is watercolor.

...ing by Tuttle Publishing Company

Published in USA by ... Publishing Company

ISBN 978-1-...-...

Dedication

First, I want to thank and give God all the honor, glory, and praise for restoring the gift of painting after 35 years of non-painting as an artist and allowing me to share His word through my paintings.

I dedicate this book to my parents and godmother.

To my loving parents, Lorenzo A. Wyche and Georgia E. Wyche, who are deceased: It was their encouraging words to follow my dreams and to never give up that made me the woman that I am today.

Mrs. Mary Adalia Howell Miller, my godmother, who passed away, played a significant role in my life, encouraging me from a young child to an adult. When my family could not attend my first ordination ceremony, she was there with her family, giving me that smile I remembered as a little girl.

ACKNOWLEDGEMENTS

My dear dad, whom I learned so much from. He was a self-made businessman who was the first African American in the 1960s to open and own a business in Rochdale Village, Queens, N.Y. I thank my dad for our talks. I will always remember him telling me doubt brings fear, and fear stops you from achieving your dreams.

My dear mom, who showed me age does not matter. What matters is what you decide to do with your life. Make sure to see what's going on around you before you make any decisions. Mom made sure I had the best education, and I thank her for seeing more in me than I saw in myself.

I thank my husband, William R. Hopton Jr., who always supports and encourages me with love and patience. He is my confidant and friend, whom I love very much.

I thank all the artists I've met over the years who taught, critiqued, shared, and encouraged me as an artist.

Thanks to all the pastors who I worked with in the ministry as their associates.

I am grateful to the two small congregations I had the privilege of pastoring who never gave up on serving God and their community.

TABLE OF CONTENTS

INTRODUCTION

This book is a celebration of womanhood, resilience, and the unwavering strength found in faith. It is a testament to the remarkable journeys of women of color, whose stories serve as beacons of hope and inspiration to us all.

Inspired by my virtual art show, "Women of Color," each painting possessed a unique story. I felt compelled to amplify the voices of the women I had encountered throughout my life. Through a blend of fiction and non-fiction, "Women of Color, Telling Their Story," brings to life the diverse narratives of women who have found solace and courage in their relationship with God, providing valuable insights and guidance for their own journey.

Readers will find a collection of stories that touch on universal themes such as hope, doubt, shame, strength, and faith. Their stories are poised to resonate with Christian women's study groups, book clubs, and readers seeking inspiration and encouragement.

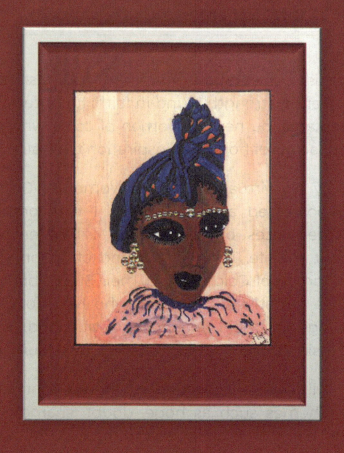

Auntie Betty
HOPE

Auntie Betty is known to be full of wisdom. She loves her jewelry and make-up. She's not afraid to push the limit on her face, make-up, and hair. In church, she needs no introduction because her posture always reveals it. Don't mess with Auntie Betty.

When situations are hopeless, you must be reminded that you can always turn to the word of God. You will receive direction and guidance for your physical, financial, and spiritual needs. Let Auntie Betty tell you that you can't have hope without faith, and you can't have faith without hope.

My dear children, let's first define what hope is. Hope is the conviction that one can attain, reach, and realize their desires.

So, there is an expectation of attaining what you desire. Did you know that hope is the goal-setter? How many of you have thought about becoming a doctor, lawyer, teacher, preacher, technologist, nurse, inventor, missionary, entrepreneur, musician, or having a successful and loving marriage? To attain these desires, you must set some goals, hoping that you will be able to reach them. Listen, if you don't set any goals or know where you are going, how will you know when you get there? Goals give you direction.

One of my favorite scriptures in the Bible is, *"Now faith is the substance of things hoped for, the evidence of things not seen."* Hebrews 11:1 NKJV

This scripture tells us about faith. Let Auntie Betty break it down for you. Faith is your confidence, loyalty, and belief. Did you know that this is an action word that keeps you

going in the direction where God wants you to go? Faith takes away fear, doubt, and idleness. How? Because of your hope. Faith and hope are partners. Also, did you know that faith is God's divine energy?

Let me tell you about this woman in the gospel of Mark 5. There was a woman who had female issues that had her bleeding all the time. She spent all of her money trying to find the right doctor to get her well, but they could not heal her from this female bleeding issue. One day, she heard about Jesus, who was healing so many people who suffered from various sicknesses and diseases. She said to herself, *"If only I could touch the hem of his garment."* That was her hope, if she could only touch the bottom of Jesus clothes, and her faith was that she would be healed. It was then that her hope and faith empowered her to receive healing. Jesus felt the virtue leave Him; He felt her faith and hope. So, Jesus let her know it was her faith in Him that healed her immediately. Now, you may not be suffering like this woman, but you may need the Lord to do something for you. So, I leave y'all with this: know that hope does not disappoint. Your faith in God will empower you to keep going until your change comes.

I hope to see you in church next Sunday. I have faith that you will give your life to the Lord. I'll be sitting in the third row, close to the aisle on the right-hand side.

God bless you, from your loving *Auntie Betty.*

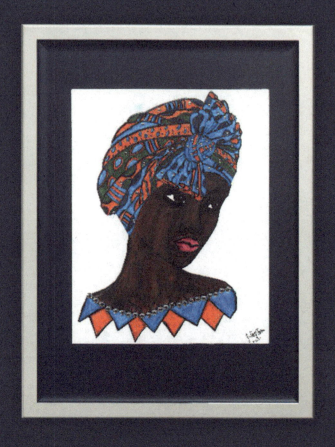

SISTA IRENE
DOUBT

Beautiful Sista Irene, with chocolate skin that glows in the moonlight, along with her big black and brown eyes. But you can tell that she wants to say something to us. So, let's hear her story.

I'm Sista Irene, and I used to doubt myself all the time. I wanted the approval of those around me, but I realized that they could not fill that void in me. So, when I became a Christian and joined a women's bible study, I found out all about the word doubt.

First, I had to face the fact that doubt is defined as an uncertainty of belief or lack of confidence in something. I found out that doubt is the opposite of hope. And when I applied that to my Christian life in God, I could see that if I held onto having doubt, I would also be doubting God's word, His work, and the blessings He has for me. Oh my, I never want to doubt God. I found this scripture: *"The fool has said in his heart that there is no God, they are corrupt, they have done abominable works, and there is none who does good."* Psalms 14:1 NKJV. I am so glad to be born again and redeemed from all my sins. I am a new creature, born into God's family.

Let me get back to doubt. You know, I have some friends who are Christians, and they have told me how some of their family members are backsliding. They know the word of God; they say they believe in Him, yet they do things that aren't in God's will for their lives. They have experienced some things that have affected their lives and those of their loved ones, so their faith and trust in God are questioned.

Their lives seem to have turned upside down, and many doubts if they will turn right side up.

But I remember a lesson from my Bible study class about a man named Joseph, whose life turned upside down. He was sold by his brothers, who hated him, especially when he shared his dream of how his brothers would one day bow down to him. That dream pushed them to the edge.

They tried to kill him, but instead he was sold to this nation called the Midianites. The Midianites then sold Joseph to Potiphar, who was an officer of Pharaoh and captain of the guard in Egypt. Meanwhile, Jacob, the father of Joseph, was told that his son was dead.

I thought about Joseph, his relationship with God, and his dream. I wonder if Joseph doubted what God revealed to him in his dream. Why was he going through this?

Sometimes we are not privy to comprehending everything that happens to us. God did not make it so that everyone could see it in the future. The prophet Isaiah reveals to us how God thinks: *"For my thoughts are not your thoughts, nor are your ways, says the Lord. For as the heavens are higher than the earth, so are my ways higher than your ways and my thoughts than your thoughts."* Isaiah 55:8–9 NKJV

Famine broke out in the land of Canaan, and Joseph's brothers had to come to Egypt for food. Well, as the story goes, they had to come before Joseph and bow down, just like in Joseph's dream.

But that's not the end of the story. Joseph recognized them, but they did not recognize him. When they finally did, they were so apologetic and afraid. Joseph had them bring him his brother, and he kept one of the brothers until they came back. A little later, the father was brought to Egypt. The story goes that the Egyptians gave all of Israel not only food but also land to live on.

What's the moral of this story? When things don't go our way or our world turns upside down, we shouldn't doubt God. Look to see what God is doing or going to do. If Joseph had not been sold and experienced all that he did, the children of Israel would have starved to death. Read the story for yourselves.

Although Joseph's life story is not ordinary for our times, it still lets me know that there is nothing impossible for God, especially when we don't doubt Him.

While studying the Bible, I learned these lyrics, and the words go like this: *You can't make me doubt Him because I know too much about Him. You can't make me doubt Him in my heart.*[1]

Well, have a good day. I hope you join a Bible study group like I did. You will be blessed to find out more about God's character and about yourself.

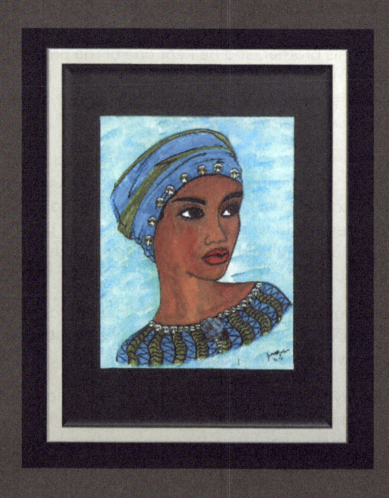

SISTA ALVENA
SHAME

Sista Alvena does not play when it comes to spreading God's word and sharing the love of Jesus. Her skin tone is light brown with red tones. Her eyes are mysterious for those who just met her, but when you get to know her, you'll see that those eyes reflect how serious she is about spreading the gospel of Jesus Christ.

Let's hear what she has to say.

Hi everyone, I'm Sista Alvena. The gospel is the greatest news. It saves and transforms lives because of Jesus Christ, His life, and His atoning death. God transforms us with His love. He transformed me. I was always ashamed because of the color of my skin and my family's history. I heard things like, "You're so bright, you think you're white," or "Who's your daddy and your mama?" "You don't look like your sister, Irene." I'm so glad I found Jesus. Now, if anyone says anything about the color of my skin or if you are sure you belong to your family, I reply with the word of God. Man sees the outside of a person; God looks at what's on the inside of a person. In me, He sees that I gave my life to Christ; I am a new creature; I am filled with His Holy Spirit; I'm His child; and I belong to His family. I no longer walk around in shame! I know who I am and who I belong to, and I'm not ashamed to share the good news if you are willing to listen.

One of my favorite scriptures is written by the Apostle Paul: *"For I am not ashamed of the gospel of Christ. For it is the power of God, of salvation for everyone who believes, for the Jews first and for the Greeks."* Romans 1:16 NKJV

I liked Paul's ministry because he understood the actual cost of being a disciple. In fact, I questioned why he would share with the church that he's not ashamed.

When you read his bio, you will read how he went around supporting killing Christians, the new believers in Christ Jesus. One day, he had an experience with Jesus Christ on the road to Damascus. Jesus blinded him for three days, and when he received his sight, he accepted Christianity. While in prison, Paul traveled and planted churches, endured beatings and imprisonment, and composed numerous letters to churches, urging them to live as true followers of Jesus Christ. Also, Paul was trying to encourage the church members to share the gospel, like our pastors, evangelists, and spiritual teachers do today. People need to hear and share this good news about salvation, which is the power of Almighty God. We are saved from our sins and have eternal life. I notice there are people today who think the gospel is foolishness, believing it's just a story and not understanding that this is real history and has authentic documentation. In 1 Corinthian 1:18 NKJV, Paul wrote to the church, stating, "For the message of the cross is foolishness to those who are perishing, but to us who are saving, it is the power of God."

Have a blessed day everyone!

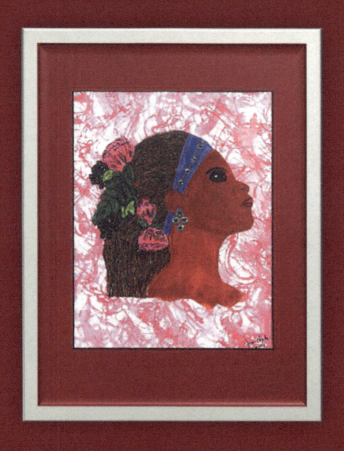

FIRST LADY CECE NUMBI
STRENGTH

CeCe Numbi, with her beautiful reddish brown skin tone, long neck, and brown braided hair flowing down her back, just got married. She is now the first lady of a huge congregation that her husband pastors. As a young woman, she will be responsible and supportive of many things in her new position. Although she is incredibly positive and has a love for the Lord, she realizes that she still needs strength. So, let's hear what the First Lady has to say about strength.

First Lady speaking: "How many times have you said, Lord Jesus, give me strength?" I know for myself. I ask every day, "Lord, please be my strength. I need You every second, minute, and hour." Now that I'm the pastor's wife, I say it more than ever: "The Lord is my rock, my fortress, and my deliverance."

Let me teach you something about strength. The Webster dictionary defined it as a property of being strong, a force of energy, power, support, vigor, and intensity. These words hold me together to know that when I ask God for strength, I'm acknowledging that He is my stronghold, that place of security. This brings me to my favorite: *"I will love you, O Lord, my strength. The Lord is my rock, my fortress, and my deliverer; my God, my strength, in whom I will trust; my shield and the horn of my salvation, my stronghold. I will call upon the Lord, who is worthy to be praised; so shall I be saved from my enemies."* Psalm 18:1-3 NKJV

This psalm is one of King David's most praiseworthy compositions. David expresses his faith, love, joy, praise,

hope, and all his feelings. Did you know that most of David's Psalms are accompanied by music? I love music.

So, when I read this Psalm, I interpret these words and speak them to God: You are my strength, my force of energy, an inherent power to operate, my power; You give me the ability to act or do, to have authority and influence; You are my support, my provider, and my helper; Your vigor is my strength of mind with intensity and an extreme amount of energy. Then I feel like I can do anything through Christ, who strengthens me.

As First Lady, I look forward to keeping my husband encouraged and focusing on my role as First Lady to be helpful wherever needed in the ministry. When times get tough and the enemy rises his ugly head in this ministry, I remember these words from the mouth of our Lord and Savior Jesus Christ: Come to Me, all you who labor and are heavy-laden, and I will give you rest. Because we do not wrestle against flesh and blood but against principalities, against powers, against the ruler of the darkness of this age, against spiritual hosts of wickedness in the heavenly places, these ladies will need to recognize that without God, we will not have the strength or power to walk this journey on our own. So, keep hope; don't doubt or be ashamed of the gospel, because we are all given the strength to run this race with the help of the Holy Ghost in Jesus name.

This reminds me of the song Jesus on the Mainline, which we sing on those Sundays for God's strength.

Call Him up, Call Him up, and tell Him what you want

Call Him up, Call Him up, and tell Him what you want
If you need your body healed, tell Him what you want.
If you need His strength, tell Him what you want.
Just call Him up! Call Him up! [2]

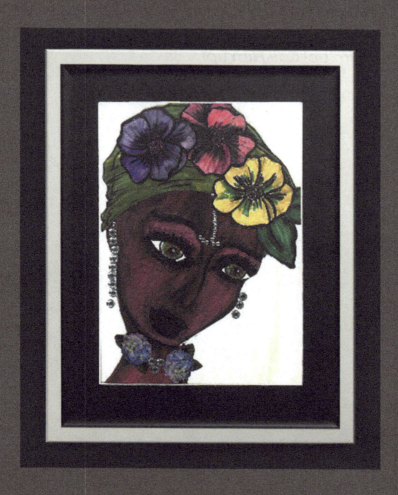

COUSIN THELMA
FAITH

She is a woman of courage and a notable missionary. She has piercing hazel eyes, an elongated nose, and a narrow body. She loves to travel all over the world and would not be able to go to those remote places without having faith in God.

Listen to what Cousin Thelma wants to share with you about faith.

Praise God, from whom all blessings flow! How do you evaluate your spiritual life? I have come across so many people who are struggling with a lukewarm spirit. Frustrated with life and disappointments. They want to do more but are not satisfied with their level of spiritual growth. I believe during this Christian journey we have all gone through this process. But then something happens, and change comes when we get a true understanding of faith.

So, let me share with you what I know about faith. Our Bible tells us in Hebrews 11:1 NKJV, *"Now faith is the substance of things hoped for and evidence of things not seen."*

The Webster Dictionary states that faith is confidence, loyalty, or belief. And belief in God. The word "belief" is defined as accepting the truth or reality of something without certain proof. The illumination here is that I don't see it physically yet, but I know that it's coming because I believe with every fiber in my body and soul that it will come to pass, whatever it is that I am looking for, to have, and to do. Why? Because I trust in God, He will do it according to His will and for His glory.

I can remember having a dream, and in it, I heard a voice, which I knew was the Lord, telling me to prepare to leave the country. At first, I questioned what I heard, but then, without any further questions, I packed my bags for the mission. At that point, I really didn't know where God was sending me. But suddenly, I received a call from a friend while at a prayer meeting about this mission trip. Wow, look at God, airplane tickets to Africa! I still didn't know where I was staying or who would meet me. I had the faith that God would provide all that I needed.

After arriving at my destination, I heard someone call my name. Someone knew my name at the airport in another country, halfway around the world. Now that's God!

I was taken to a village where the Lord used me to minister through music and the word. Anyone who knows me knows I love to play my tambourine.

My experience reminds me of James' book, in which he says that faith is not only believing but also acting on what you believe. He expressed how faith and good works must work together for salvation. We cannot have one without the other. We cannot have faith without working to bring people to Christ Jesus. In verse seventeen, James tells us that faith by itself is dead if it does not have works. In other words, He tells us that faith alone cannot save a person without good works. Faith is an action word. So, every day we need to ask ourselves, what would Jesus have me do today?

Now, it doesn't have to be as dramatic as my experience, but you can volunteer as a missionary right here in the

States, helping in the food drives, helping in the church, and serving in your community. Whatever you do or wherever you go, know that faith and works go together because it's all about building the kingdom of God. You can find all of the names mentioned in Hebrews 11 of those who demonstrated faith and works.

It's been nice sharing with you. I just got a call from a friend to join her on a missionary trip back to Africa. She has a group that is putting in water pumps in a remote area where there is no running water. I have faith that God will provide all the pumps, and that water will be available for that community. I'll do my part, singing and praising God on my tambourine. Please pray for us. See you when I get back!

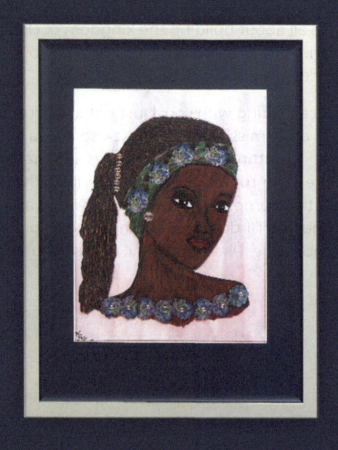

LITTLE LORI ANN
LOVE

This young girl's skin tone allows her to wear all assorted colors. Her long brown braided hair is draped to one side. She has small features and has no trouble telling you who she is and to whom she belongs.

Lori Ann will share with you her conversion when she was just a young girl, while in church school, and how she came to know Jesus' love for her.

I don't have a blog, but I do get on TikTok, Instagram, and Facebook. I see what my friends are posting, and some things are incredibly sad. I want to tell them that they don't have to run after boys in school, that they don't have to be ashamed of themselves, that they don't have to take drugs, or that they don't have to think about suicide. They need to stop sneaking around looking for love. I want to tell them about Jesus' love.

Since you have given me this platform to share what I know, I hope and pray that those who read this will know just how much God values and loves them. So let me share with you seven things that I know about Jesus.

First, Jesus gives love. *"God so loved the world that He gave His only begotten son, that whoever believes in Him would not perish but have everlasting life."* John 3:16 NKJV

Secondly, Jesus lived in love. *"As the Father loved me, I also have loved you; abide in my love."* John 15:9 NKJV

I am glad my Sunday school shared that when we abide in the love of Jesus, we find grace and mercy. Abide means to accept without rejection; grace is God's unmerited favor;

mercy is His kindness. Jesus' compassion towards us relieves us of a lot of suffering.

Thirdly, Jesus touched in love. He healed so many people. All He did was touch them, and they were healed. People who were blind, deaf, could not talk, had demons, and were sinners. Also, for those who followed him, He fed them out of love. He left no one out when they came to him for help. *"Those who are well do not need a physician, but those who are sick do. I have not come to call the righteous, but the sinners, to repentance."* Luke 5:31–32 NKJV

Fourth, Jesus taught through love. Jesus tells us, *"He is the light of the world. Whoever follows Him shall not walk in darkness but have the light of life."* John 8:12 NKJV

His words are always encouraging and full of guidance. You can find His teachings on murder, adultery, divorce, oaths, retaliation, love, charitable deeds, prayer, fasting, wealth, judgment, and false teachings.

Fifthly, He gives in love. Jesus said, *"If you abide in me and my words abide in you, you will ask what you desire, and it shall be done for you."* John 15:7 NKJV

He has given us his peace. He left us with His peace, not the world's peace. Reference John 14:2

Sixthly, Jesus died in love. *"Greater love has no one than this, than to lay down one's life for his friends."* John 15:13 NKJV

Jesus laid down his life for us. He was humiliated, beaten, and scourged. While going through all of this, he didn't say a word. He died for all our sins.

Lastly, Jesus arose in love. Jesus had resurrected, then the graves opened, and those who were dead came alive out of their graves. Many people saw them in the Holy City. Have you heard this scripture, *"O Death, where is your sting? O Hades, where is your victory?"* 1 Corinthians 15:55; Hosea 13:14. NKJV

I feel so blessed that I attended Sunday school and had wonderful teachers to teach me about Jesus' love. During Sunday school, we learned this song: *Jesus loves me this, I know, cause the Bible tells me so. Little ones to Him belong; they are weak, but He is strong. Yes, Jesus loves me. Yes, Jesus loves me. Yes, Jesus loves me, for the Bible tells me so.*[3]

Come and join me. I am now a Sunday school teacher in my church, teaching the little kids about Jesus' love.

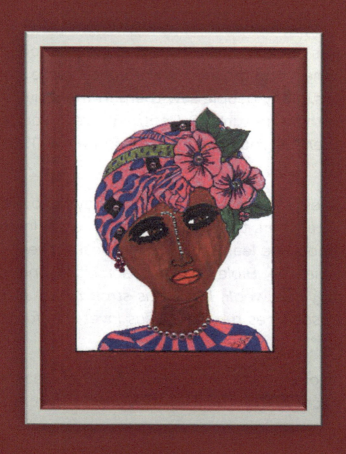

GRANDMA TESSIE
GOD PROVIDES

Grandma Tessie, with her beautiful hazel-brown eyes and reddish-brown skin tone, is wearing her pink head wrap to match her pink outfit. This grandma can tell you some things. She had the task of raising two generations, and I will tell you that it was her faith in God that allowed her to keep going and provide for her family.

Listen to what Grandma Tessie has to say.

My name is Tessielina, but they call me Tessie, Grandma Tessie. I grew up in church and feel so blessed to have worked as a missionary and church secretary. But I am not here to talk about myself; I'm here to tell you that God is our Provider and Supplier.

My favorite scripture is, *"And my God shall supply all your needs according to His riches in glory by Christ Jesus."* Philippians 4:19 NKJV

This scripture has comforted me throughout my whole adult life. Raising not only my own children but also my grandchildren is caused by matters I choose not to share at this moment. But I will say that we will all experience difficult circumstances in our lives and wonder whether God really cares. Is He personally involved in your life? Why am I going through this? Why now? Does God know my needs?

Darlings, I'm here to tell you yes! God knows all your needs. I heard a pastor say, God is a need responder. He is the one who sees and cares for all our needs. He knows every detail

of our makeup. Have you read in the Gospel of Matthew, chapter 10, where Jesus tells us that the very hairs on our heads are numbered? He knows our frame, and He remembers that we are just dust. He also tells us that we are more valuable than any sparrow. When I see those sparrows on my nice green grass having their breakfast, lunch, and dinner, I know that God will provide for me.

No matter what your situation is or what you are living through, God knows your needs. I want to encourage you by mentioning a few people from the Bible whose stories have inspired me to keep going and not give up. Those three Hebrew boys in the Book of Daniel, who were thrown in a fiery furnace because they kept their belief in God.

What happened? God delivered them, and they came out of that fiery furnace with clothes that neither burned nor smelled like they were ever in a fire. God allowed that king to see another figure in that fiery furnace, and I can only believe it was Jesus. So, you see, we're never alone, and God provides.

And what about Daniel? When he was put in the lion's den to be killed, God provided! What about David? It was God who provided him with the strength to kill that giant Goliath. What about Abraham? In the book of Genesis, God requested that Abraham sacrifice his only son. Abraham prepared his son out of obedience, and God provided a ram in the bush for the sacrifice.

God knew the needs of the children of Israel, and He knows the needs of His children who received Jesus Christ as their Savior.

I know someone reading my story is not convinced. I'll share my story now. I had to rely on God when I took on the responsibility of raising my grandchildren, who came to me with only the clothes on their backs. I knew some way, somehow, he would provide, but during that time, I was trying to make the best of what I could afford. One day at church, a member came up to me and asked if I didn't mind getting clothes for my grandchildren. Of course, I said I didn't mind. My grandchildren received name-brand jeans, shirts, and sport tops for three years. What a mighty God we serve! You see, God will supply all your needs according to His riches in glory in Christ Jesus.

I love the song that goes like this: *Jesus on the main line, tell Him what you want. Call Him up, Call Him up, and tell Him what you want. Jesus on the main line now.* [4] And what about this song? *Yes, God is real. He's real in my soul. Yes, God is real; He has washed and made me whole. His love for me is like pure gold. Yes, God is real; I can feel Him in my soul.* [5]

As I take my seat in this conversation, I encourage you not to give up praying and asking God. Although He already knows, He works on His timing; it's always the right time, and He will provide. Can I get an Amen?

Grandma Tessie loves you, and don't forget, so does God, your provider.

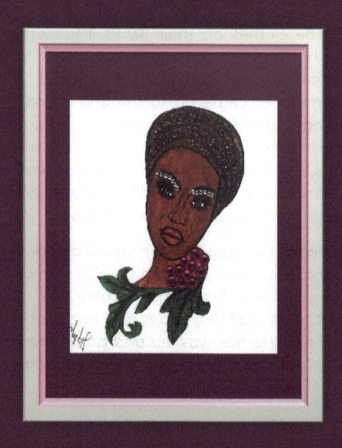

Cousin Sara
COMPASSION

A reserved woman of God. Her brown eyes seem to stare at you, no matter where you are standing. She is sizing you up to see if you have compassion.

Let's hear what cousin Sara has to say to us today.

I've had the privilege during my career to meet and work with so many people of diverse backgrounds. I have noticed one thing that is missing in our society today, and that's compassion.

Compassion causes you to do something for someone with no desire to get anything in return. Compassion describes your character; it's an action word. Did you know that God introduced this word at the beginning of time, when He created man? He wants us to have compassion for those who are less fortunate than ourselves. The Webster dictionary defines compassion as being sympathetic to the misfortunes of another, accompanied by a desire to help or to have mercy. I describe compassion as something deep inside that moves you when you see anyone who is in need, less fortunate than you, hurting, sick, or can't help where they are in life.

One Sunday morning, my pastor preached on this parable about the Good Samaritan. Let me tell you the story. There was a traveler who was stripped of his clothing. He was beaten and left for dead alongside the road. Three people saw him, and out of those three, only one had compassion for this Samaritan to help him. He cleaned him up and paid for a place for him to sleep, and he never wanted any favor in return. Now, I didn't give you all the details because you can read them yourself. I saw this man's compassion.

I believe the people of God and the church need to understand that Jesus is our leader when it comes to compassion. There are so many people all over the world who are calling for help, who need a touch, and who will not be able to return any favors or money. But they will testify of your goodness, and that's when you can lead them to Jesus Christ. Let them know that Jesus, our Savior, is seated on the right side of God the Father, who is the same yesterday, today, and tomorrow. We serve a compassionate God who wants his children, the church family, to have compassion for each other.

There is always someone who needs a touch of kindness. I've learned not to see what a person looks like on the outside, but rather what our Lord and Savior sees on the inside. Most of the time, we need to understand, care for, and refrain from passing judgment. If that Samaritan was judgmental, like the others who passed by, just imagine that this story would not be in the Bible. This story reminds me that Jesus never passes anyone by. He may not be here physically with us, but He will send someone who is compassionate to address our needs.

After the pastor finished his sermon, the choir started singing the hymn "He Touched Me" As they were singing, I envisioned in my mind not only the Good Samaritan but also the woman with the issue of blood.

He touched me, oh, He touched me, and oh, the joy that floods my soul, something happened, and now I know, He touched me and made me whole. [6]

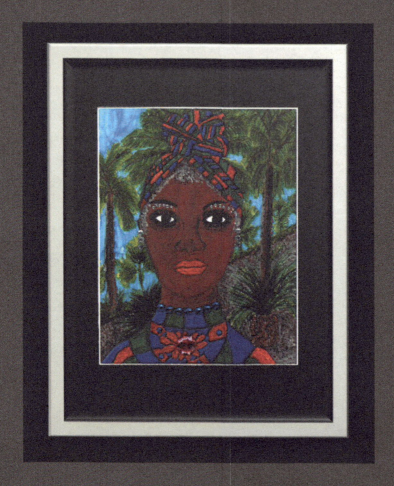

Miss Sue
GRACE

Miss Sue, who grew up in the tropics and lived off the land, now lives in a huge house surrounded by beautiful palm trees. She knows it is only God's grace that has blessed her. Her beautiful gray hair appearing from under her colorful head wrap, brown skin, and brown eyes let us know she is a well-established older woman who can share some of her wisdom.

Let us hear Miss Sue's story.

Hello, my sisters and brothers. It is so good to be in your presence. I'm an Island girl, and I have an Island accent, so I'll speak a little slow so that you can understand me. If it had not been for the Lord on my side, where would I be?

I thank God for His gift of grace. A gift that's undeserved, I didn't earn this unmerited favor. We are all sinners, every one of us, on our way to hell, but we are saved by God's grace. *"For God so loved the world that He gave His only begotten son, so that whoever believes in Him will not perish but have everlasting life."* John 3:16 NKJV

While at my church, our pastor began to explain how grace affects us. And I would like to share with you what I wrote in my notepad as the pastor was teaching.

First, grace saves us from our sin. Man sinned and was under condemnation. We needed a Savior, so God sent His son Jesus to pay the penalty that we owed. He redeemed us from the bondage of sin. Did you know that the second you trust and receive Jesus Christ as your Lord and Savior, the redeeming power of God begins to operate in you? God

forgives your sins and recognizes you as His child. So, not only does grace save you, but it also keeps you. Jude 24 says that He is able to keep you from falling and will present you faultless before the presence of His glory.

The pastor asked, "Who will keep us from falling, and who presents us as faultless?" We all said, Jesus Christ. We learned that the same grace that saves us also keeps us. It enables us to live in the world without becoming part of it. The book of Romans reminds us, *"And do not be conformed to this world, but be transformed by the renewing of your mind, that you may prove what is that good and acceptable, and perfect will of God."* Romans 12:2 NKJV

The question came up: well, how do we receive the grace of God? The pastor explained that the sinner must recognize and acknowledge their own sinfulness, as everyone has sinned and fallen short of God's glory.

As a result, there are none who are righteous. Our own standards cannot meet God's holy and righteous requirements. We must repent of our sins, then put our faith and trust in the Son of God, Jesus Christ, and He will make us acceptable to God. We become that new creature; we look the same on the outside, but something has changed on the inside, and God sees it. We are saved and secured by God's grace and His unmerited favor.

I love the song *Amazing Grace*.[7] Through this song, you can really grasp what Grace is all about. Newton knew it was God who found him, not he who found God.

Amazing grace! How sweet the sound. That saved a wretch like me! I once was lost, but now am found. Was blind, but now I see.

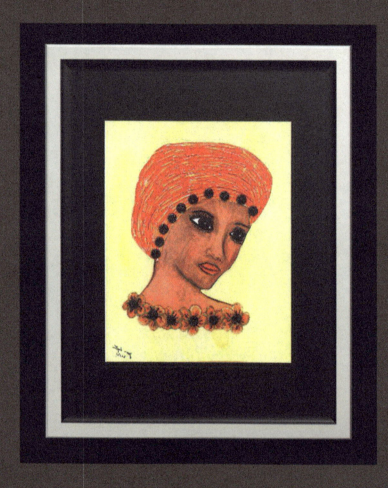

Cousin Anita
COMMITMENT

She has beautiful big brown eyes, and her skin coloring is light brown with light hues of red, making her skin tone incredibly unique. She seeks out the truth in God's word as she journeys through the life of a Christian with a purpose.

Let Cousin Anita tell her story.

I had a challenging time committing myself to anything. I have witnessed many people who have partnered with a cause, and it seemed, from my viewpoint, that it just did not work out.

I know they committed with good intentions, but for some reason, the support that was there disappeared, or in some cases, the leadership changed. So, it saddens me when I see something like this happen to good people.

I accepted an invitation to a Bible study group, which required me to dedicate a night on Zoom for the group's meetings. It also meant I had to commit to reading and taking notes. It just so happened that the class group leader took us to the disciples who followed Jesus. These disciples really gave me an understanding of commitment. I learned the Lord Jesus is right there to see me through. He committed his life to die on the cross for my sins, and because of Jesus' commitment, I can have eternal life in the Kingdom of God. He was taunted, scourged, whipped, slapped, and mocked, but He did not say a word. He died for mankind. He opened the pathway to heaven, if only we believed and accepted Him as our Savior. We cannot forget the passage in the Bible where Satan taunted Jesus for 40

days, but Jesus refused to give in. He was committed to endure so that we could get through all our trials and tribulations here on earth. Jesus knows what it feels like and understands what we go through because of Satan's trickery and attacks on our lives. I'm so glad and blessed to know that Jesus is my advocate, sitting on the right side of our Father in heaven, interceding on my behalf. If Jesus had not committed himself, if his disciples had not committed themselves, if my ancestors had not committed themselves fighting for freedom and voting rights, I would not have come through many mountains in my life. Therefore, I dedicate myself to my Savior, and I am fully committed to any task I undertake.

If you are having a problem with commitment, do like I did: pray and read the Bible. Let God's Holy Spirit guide you. Then, commitment will become easy. You're welcome to join me at Sunday school. I know my purpose in life, and I'm committed to doing the will of God wherever it leads me.

There is a hymn the choir sings at church, and every time I hear the words, my spirit is lifted. I know that whatever commitment I have made to do God's work, it will be done.

Lead me, guide me along the way, for if you lead me, I cannot stray. Lord, let me walk each day with thee, Lead me, oh Lord, lead me.[8]

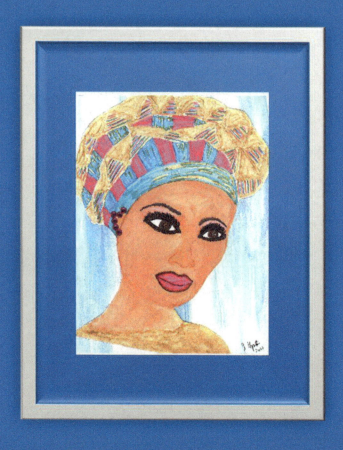

Sista Lydia
PRAYER

Sista Lydia loves to sing and sew. She has high cheek bones, light skin, and light brown eyes. She is not a woman who is into face decorations, but she loves her gold. She made her own head wrap, which included gold material. You may hear her humming the tune: "I sing because I'm happy, and I sing because I'm free." His eyes are on the sparrow, and I know He's watching over me.

I would like to share my story if you listen.

I used to sing soprano in my church choir. Oh, how I loved hitting those high notes. Every time those notes came out of my mouth; I knew that it was not me; it was God. One day my throat was sore, and it would not go away.

I went to the nose, throat, and ear doctor. They found polyps on my vocal cords. I was devastated. Would I be able to sing again? *Oh, no, God, You must heal me; You must make a way for me to sing again. I want to keep hitting those high notes because I know it's only You who have given me those notes to sing.*

So, during this time of keeping silent and not singing, I began attending prayer meetings. At first, I knew it was for selfish reasons, thinking of only my problems, but as I continued to attend, I began to understand what prayer was all about.

So, let me share a few things that I learned about prayer. First, I began to realize it was more than just singing in the church choir; it was more than hitting those high notes. I found out through prayer that a relationship with God is

what He wants and looks for. I found out that I had not built a good relationship with God. I read where Jesus was always praying. He went to God, the Father, for strength and direction to intercede for us. Even his disciples saw that prayer was especially important. They asked Jesus to teach them how to pray. Just like the disciples back in those days, I realized that I too needed direction to be Christ-like. I could no longer be complacent in my spiritual growth. It was no longer about me singing and hitting those high notes. I used to enjoy singing and watching the congregation shout with emotion, but now, in my spirit, it's all about glorifying God. Finally, the time had come for me to see the throat doctor. There, I was given the okay to sing again. I was filled with joy but felt different. I immediately bowed my head in prayer and thanked God. I realize He allowed me to go through this, and I'm so thankful I did. I passed his test.

When I returned to the choir loft, it was not about me or the high notes; it was all about God. My prayer was, "Father in Heaven, when I sing, I want you to receive glory." I also asked for the anointing of the Holy Spirit to manifest Himself in me, so no matter what songs were chosen for that morning's worship, the anointing would flow and bring someone to Christ. In Jesus' name, I ask this.

I just want to encourage others who may be experiencing the same thing as myself. My favorite song is *If I can help somebody along the way, if I can help somebody with a word or song, if I can help somebody from doing wrong, then my living shall not be in vain.* [9]

I thank God for this opportunity to share my story. I hope it has helped someone.

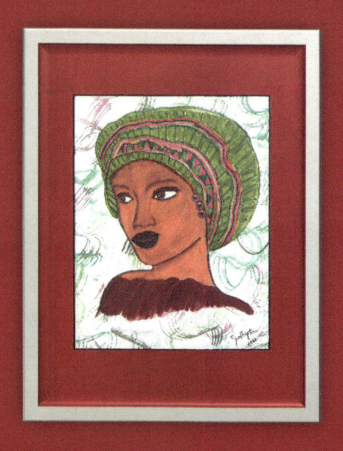

Sista Sierra
OVERCOMER

Sister Sierra loves this scripture: *"Yet in all things, we are more than conquerors through Him who loved us."* Romans 8:37 NKJV

Life is full of unexpected disappointments and joy, but I learned from attending missionary classes and from the senior women in my church that I am an overcomer, conqueror, and victorious because of Jesus Christ.

I have a friend who left her country for a short while to bring well water pumps into this small African village. As she was traveling through Africa, she heard of certain villages that did not have running water.

The water they were using came from the nearby river, which was not clean to drink. That small river provides a place to wash clothes and their cooking utensils. Additionally, the river provides drinking water. So, while on this trip, the Holy Spirit began to reveal to her the need to help these people. When she said yes, the rest was history. She was able to gather a team that volunteered, raised money, and took a trip to the village to see water pumps placed in the ground to provide water.

I shared this story with you so that you can see that God did miraculous things not only for the children of Israel but also for God's children today. God is still raising workers for the field of missions. We are to look at ourselves as overcomers and conquerors. Encourage yourself with the word of God. I can do all things through Christ, who strengthens me. There is nothing too hard for God. He will never leave me or forsake me. I believe in my Savior, Jesus Christ, who is

seated on the right-hand side of the Father. I listened for my marching orders from God, who says to be ready in season and out of season. He may send me to a place out of my comfort zone to help a group of people, and I know He will provide for me those things I'll need to carry out His will.

What would you do if God placed it on your heart to leave your home and country to help people from another country?

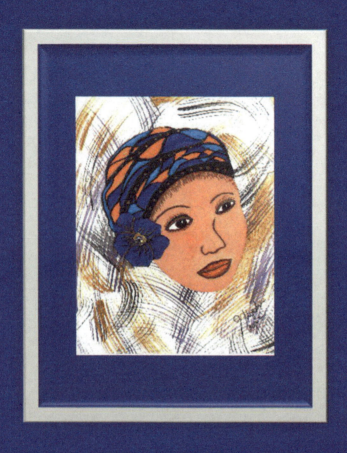

SISTAH ANNE
THE ANOINTING

Anointing, fall on me, Anointing, fall on me, let the power of the Holy Ghost fall on me, Anointing fall on me.[10] *I love to sing this song.*

"As for you, the anointing you received from him remains in you, and you do not need anyone to teach you. But as his anointing teaches you about all things and as that anointing is real, not counterfeit—just as it has taught you, remain in him." 1 John 2:27 NIV

The anointing is the Holy Spirit's power. Did you know that God gave instructions on how to make an anointing oil, which the priest needed to minister to God, before the introduction of the Holy Spirit on the Day of Pentecost? This oil was symbolic of the Holy Spirit.

This oil was made with *Myrrh*, which was used to deaden pain. While Jesus was on the cross, people offered him this spice, but he refused to accept it. Jesus took in all our pain.

The second oil used was Cinnamon oil, from the cinnamon fruit, which is known to be very flammable and is used to ignite fires. John the Baptist said Jesus would baptize us with the Holy Ghost and fire. This fire ignites, representing the energy and zeal for the things of God. To do His will and empower the people to spread the gospel.

Calamus, the third spice, is responsible for blossoming flowery petals. To get the sweet fragrance from the pedals, they had to be crushed and bruised. Jesus would be bruised for our iniquities. He would be crushed and wounded.

The last spice is *Cassia,* which means to split or scrape off. It was made from the bark of a tree and used as a laxative. So, it represented purification—a cleaning out. So, this anointing oil represented all that our Lord and Savior Jesus Christ would go through—all our sins washed away by the blood of Jesus Christ, the Lamb of God, to make us right before Almighty God.

We are so blessed. Why? Because *"God so loved the world that he sent His only begotten Son, that whoever believes in Him will not perish but have everlasting life."* John 3:16 NKJV Jesus, my Lord and Savior, died for me and you. He rose from the dead and sits on the right side of the Father. But know this: those who received Jesus Christ were promised the gift of the Holy Spirit, the anointing, to empower us for service. He is smearing, pouring out, and releasing his fragrance, setting us on fire in the Holy Spirit, preparing us for a specific function or purpose.

Oh, I want to add that God gave the people specific instructions not to make up this anointing oil using the ingredients or spices that He had for the priest in the Old Testament.

Anointing Fall on Me!

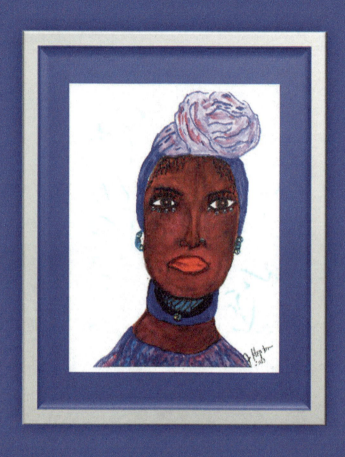

Rachel
THE HOLY SPIRIT

On this Sunday morning, when I woke up, I felt that something different was about to happen to me. I couldn't really put my finger on it, but one thing I knew was that I couldn't wait to get to church. You see, Sunday night was the beginning of the church revival, and the guest evangelist was known to be an anointed woman of God. When she came onto the church grounds, you knew that it was only God who sent her and to look for a blessing. I was excited, yet a little nervous.

The service started off high, with the choirs singing and everyone praising God. Then the evangelist stood up, looked up at the ceiling as if she were seeing God, and began to pray. Then she began to expound on the scripture that had been read earlier.

"But you have an anointing from the Holy One, and you know all things... But the anointing which you have received from Him abides in you, and you do not need that anyone teach you; but as the same anointing teaches you concerning all things, and is true, and is not a lie, and just as it has taught you, you will abide in Him." 1 John 2:20, 27 NKJV

Now I've heard that scripture, and I even read it by myself, but when this evangelist began to give the understanding, I knew that I was going to another level in God.

So, I'll share a few of my notes with you about God's anointing in us.

Because I'm a believer, I received an unction, which is another word for anointing. When we are born again, the

Holy Spirit's anointing comes and lives in us. This means we asked God to forgive us of our sins and receive His Son, Jesus Christ, as our personal savior. During our confession, God forgives all of our sins and puts in us the Holy Spirit, which is the Spirit of Christ. We are now in a new family, with God the Father, God the Son, and God the Holy Spirit. Born again in a new family. Do you remember the story of Nicodemus, who asked Jesus, how can I be born again? He asked Jesus how an old man can be born when he is old. Can he enter his mother's womb a second time and be born? Right there, I was wondering if this man, Nicodemus, was playing Jesus. But I saw how Jesus answered back. Look for yourself in the Gospel of John, chapter 3.

This new birth is supernatural, and it's the only way you will see the Kingdom of God.

Instead of Jesus Christ being in the flesh, walking around teaching and healing the sick, deaf, blind, and lame, only able to reach those who are physically around Him, Jesus is now able to reach every believer on the planet through his Holy Spirit. The Holy Spirit is our Comforter, Counselor, Helper, Intercessor, Advocate, and Strengthener, while Jesus sits on the right-hand side of God, interceding on our behalf.

The Holy Spirit is all the above; He is with you, called to help and guide you into all truths. He'll show you all the truth if you just be still and listen.

We can call upon God in the name of Jesus and ask that His Spirit manifest Himself in you so that you may get through whatever is happening in your life, with him along to help.

I hope you realize that you are not walking this Christian life by yourselves. We may not have the physical Jesus, the Word that became flesh and dwelled among us. But we do have His spirit, the Holy Ghost.

This is why I never feel alone. The words to that old hymn, *In the Garden*,[11] come to mind.

I come to the garden alone.
While the dew is still on the roses
And the voice I hear, falling on my ear
The Son of God discloses.
And He walks with me
And He talks with me
And He tells me I am His own
And the joy we share as we tarry there
None other has ever known.

I close with this: You're never alone. Jesus promised us that He would never leave us or forsake us. So, I pray that you ask God to forgive you of all your sins and receive Jesus Christ as your personal Savior, so that you can receive God's gift, the Holy Spirit.

ABOUT THE AUTHOR

Joan Hopton has served in the ministry for 38 years as of 2024. Born in Brooklyn, N.Y. Her parents moved to Long Island, N.Y., in 1967, where she graduated from Roosevelt High School in the class of 1968. She attended Nassau Community College and graduated with an associate degree. After getting married in 1970, she continued her education in art education 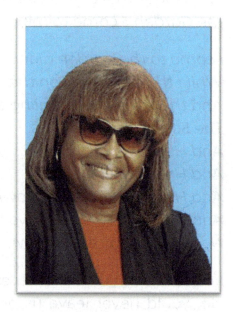 with a minor in education, receiving her Bachelor of Arts degree.

It was in 1986 that she received her calling into the ministry to preach and set aside painting. It wasn't until 35 years later that she began to paint again, using watercolors and acrylic paints as her medium to paint the caricatures in this book.

The inspiration for writing and exhibiting her art works comes from remembering all the women of all ages she has met throughout her ministry and life in conversation, bible study, church, and travel.

By God's grace and with much thanksgiving, her prayer is that this book will encourage each reader as they read and picture the characters speaking to them.

CITATIONS

1. Unknown. "You can't make me doubt Him",
 www.allgospellyrics.com

2. Unknown. "Jesus on the Mainline", The National Baptist
 Hymnal, 21st Century Edition, #270

3. Warner, Anna B. "Jesus loves me, this I know." AME
 Hymnal, 2000, The African Methodist Episcopal Church,
 sixth Printing Copywrite 2004, p. 549

4. Unknown. "Jesus on the Mainline", The National Baptist
 Hymnal, 21st Century Edition, #270

5. Morris, Kenneth. "Yes, God is Real." AME Hymnal, 2000,
 The African Methodist Episcopal Church, sixth Printing
 Copywrite 2004, p. 361

6. Gaither, William J. "He Touched Me." AME Hymnal, 2000,
 The African Methodist Episcopal Church, sixth Printing
 Copywrite 2004, p. 402

7. Newton, John. "Amazing Grace." AME Hymnal, 2000, The
 African Methodist Episcopal Church, sixth Printing
 Copywrite 2004, p. 226

8. Akers, Doris. "Lead Me, Guide Me." AME Hymnal, 2000,
 The African Methodist Episcopal Church, sixth Printing
 Copywrite 2004, p. 378

9. Androzzo, Alma Bazel. "If I Can Help Somebody", published by Boosey & Hawkes Ltd., London 1945

10. Thomas, Donn C. "Anointing Fall on Me", African American Heritage Hymnal. #318, 2001, GIA Publications Inc, Chicago.

11. Miles, C. Austin. "I come to the garden alone." AME Hymnal, 2000, The African Methodist Episcopal Church, sixth Printing Copywrite 2004, p. 452

Made in the USA
Columbia, SC
02 December 2024

47009379R00043